Catalogue of Netsukè

CATALOGUE

of

NETSUKÈ

NEY WOLFSKILL
LOAN COLLECTION

JAPANESE SECTION
GOLDEN GATE PARK MUSEUM
SAN FRANCISCO
1916

NOTE

In placing this collection before the public my one desire is that it may prove an incentive to the study of, and a means of instruction into, the customs and ideals of the real Japan. With this end in view, the collection was undertaken with the aim and desire of making it generally comprehensive rather than confining it to richness of workmanship. � *I wish to make acknowledgment to Mr. G. T. Marsh of San Francisco for his invaluable aid in compiling this Catalogue. The knowledge necessary to accurately describe a collection of this kind can be possessed only by one who, like Mr. Marsh, has placed at his command a wealth of information of the art, legends and folk-lore of Japan.* ✠ *I invite you to study these objects, feeling sure that, in so doing, you will share with me the pleasure I have had in collecting and describing them.*

NEY WOLFSKILL

CATALOGUE
o f
NETSUKÈ

ROM the standpoint of adornment the Netsukè for the past three centuries has been to the people of Japan what jewelry was to others, the Japanese being the only nation known that did not use jewels and metals for bodily adornment.

The Netsukè is distinctly Japanese—is an article of utility as well as adornment worn only by the men—is a toggle affixed by a cord to the tobacco pouch and pipe case, the Inro or the Yatatè (portable writing brush), or anything which a man may desire to suspend from his girdle, its purport being to prevent the suspended pouch—or other—from slipping, and is particularly adaptable to their form of dress, which always requires .a waist band. It has no class distinction and is worn by both peer and peasant.

Any durable substance may have been used in . its construction, though wood and ivory are the most general, the latter being the most common in the later periods, whilst the best examples of the early periods—dating from about the middle of the seventeenth century—were more often to be found in wood.

There are two very popular forms of Netsukè—
the "Manju," from its shape being like a rice cake,
and the "Kagami Buta," resembling a mirror set
in a frame. For the former the material is worked
into a button form and thereon designed. For the
latter a plate (often metal) is used as an insert in
a casing of different material.

CATALOGUE

*The dates given for each item denote the period within which
the work was executed, and not the life age of the artist. The
references (e. g. "See Sthi Fuku Jin") are to the Explanatory
Notes at the end of the Catalogue.*

1. IVORY. Daikoku: The God of Wealth and Pros-
 perity—one of the Sthi Fuku Jin or Seven House-
 hold Gods of Japan. *By* Rio Zan, 1850-1900.

2. IVORY. Ebisu: God of Good Living. *By* Rio Zan,
 1850-1900.

3. IVORY. Hotei (Santa Claus): God of Pleasure and
 Lover of Children. *By* Rio Zan, 1850-1900.

4. IVORY. Bishia Mon: God of War. *By* Rio Zan,
 1850-1900.

5. IVORY. Juro Jin: God of Longevity. *By* Rio Zan,
 1850-1900.

6. IVORY. Fuku Roku Jin: God of Wisdom. *By* Rio
 Zan, 1850-1900.

7. IVORY. Benten: Goddess of Purity. *By* Rio Zan,
 1850-1900. *See "Sthi Fuku Jin."*

8. IVORY. Daikoku lying on his back with new year
 minstrels rattle and fan in hand, supporting the
 Hoo bird-ship of plenty, carrying the other Six
 Household Gods. *By* Koichi, 1850-1900.

9. IVORY. Daikoku and Goban Dai with Doll. *By*
 Masa Yuki, 1850-1900.

10. IVORY. Daikoku struggling with sack of rice. *By* Munemasa, 1850-1900.

11. IVORY. Daikoku carrying a sack of rice. *By* Toichi, 1800-1850.

12. IVORY. Yebisu and Daikoku wrestling. 1700-1750.

13. IVORY. Yebisu holding down the Tai. *By* Masa Tsugu, 1850-1900.

14. IVORY. Yebisu carrying Tai. 1750-1800.

15. IVORY. Yebisu holding down the Tai-fish (the struggle for sustenance). 1800-1850.

16. IVORY. Yebisu and Tai. 1850-1900.

17. IVORY. Hotei with his six fellow Household Gods in his bag. *By* Masa Kadzu, 1850-1900.

18. IVORY. Hotei reclining, two children trying to pull him up. *By* Yoshi Aki, 1850-1900.

19. IVORY. Hotei with Fan. *By* Yoshi Naga, 1750-1800.

20. WOOD. Sleeping Hotei. 1700-1750.

21. IVORY. Hotei with Fan. 1700-1750.

22. IVORY. Child and Hotei using his emblem bag as a boat and playing Kubi shiki (neck strength). *By* Gyokuzan, 1850-1900.

23. WOOD. Hotei in his youth. *By* Ho Jitsu; made at age of 67. 1800-1850.

24. IVORY. Hotei sleeping. 1650-1700.

25. IVORY. Hotei dancing. 1850-1900.

26. IVORY. Hotei with boots and trousers (from the Chinese). 1700-1750.

27. IVORY. Hotei playing hand-ball with his stomach. *By* Masa Nao II, 1800-1850.

[7]

28. WOOD Hotei within his treasure bag. *By* Shugetsu, 1800-1850.

29. IVORY. Daikoku and Mammoth Dikon (White Radish). *By* Gyoku Yosai, 1800-1850.

30. IVORY. Kubi Shiki—a test of neck strength by Daikoku (God of Wealth) and Bishiumon (God of War). 1850-1900.

31. IVORY. Fukurokujin (God of Wisdom in miniature) with deer. 1700-1750.

32. IVORY. Fukurokujin. 1850-1900.

33. IVORY. Juro Jin (God of Longevity) riding on stork. *By* Masa Yuki, 1850-1900.

34. IVORY. Hotei and Fukurokujin. 1850-1900.

35. IVORY. Children drawing cart loaded with Takaramono (emblems of prosperity). *By* Masa toshi, 1800-1850. *See "Takaramono."*

36. WOOD. With Inlays. Bag of Takara mono. *By* Shibiyama II, 1850-1900.

37. IVORY. Five Karako (happy children, from the Chinese) playing with Hotei's bag of treasures. 1750-1800. *See "Sthi Fuku Jin."*

38. IVORY. Karako (happy children) playing with Hotei's bag. 1700-1750.

39. IVORY. Two Karako (children) with mask. 1700-1750.

40. IVORY. Three Karako playing. 1750-1800.

41. IVORY. Two Karako with snow ball. 1700-1750.

42. IVORY. Three children watching the kites. 1850-1900.

43. IVORY. Karako with gourd and bag. *By* Masa Mitsu, 1700-1750.

44. IVORY. Boy and Rabbit. *By* Ko Gyoku, 1850-1900.

45. IVORY. INLAYS OF SHELL, CORAL AND KOKUTAN WOOD. Child and Drum. *By* Gyokumin, 1850-1900.

46. IVORY. Karako with dog and bag. 1700-1750.

47. BOX WOOD. Tama Nage, child playing with two balls. *By* Ranshige, 1750-1800.

48. IVORY. Karako. Child with bag of luck emblems. 1850-1900.

49. IVORY. Okami (Girls' goddess of mirth) as a geisha standing on Sambo (ceremonial service stand). 1850-1900.

50. WOOD AND SILVER. Okami carrying dog. *By* Yasu Chika. 1800-1850.

51. BONE. Okami (Uzume), Goddess of Mirth, with mammoth toadstool. *By* Shugetsu, 1800-1850.

52. WOOD. Originally coated in colors. Okami dancing. *By* Shuzan I, 1700-1750.

53. IVORY. A man acting the character of Uzume (Okami, the Goddess of Pleasure). 1850-1900.

54. WOOD. Okami contemplating Tengu mask. *By* Toshi ichi, 1850-1900. *See "Tengu."*

55. WOOD AND IVORY INLAY. Okami sleeping whilst resting on an abalone shellfish. 1850-1900.

56. WOOD AND IVORY INLAY. Okami as a court lady. *By* To Min, 1850-1900.

57. IVORY. Otafuka (Fukusuke) and Uzume returning from a fete with branch of New Year emblems. *By* Masa fume, 1850-1900.

58. SENTOKU BRONZE. Fukusuke (The boys' god of mirth). 1750-1800.

[9]

59. WOOD. Fukusuke (God of Fun) standing on a theatre stool and carrying a lunch box on which is inscribed "soup bowls for ten people." 1750-1800.

60. BLACK HORN. Fukusuke. 1800-1850.

61. IVORY. Manzai dancer and saizo performer. *By* Shuzan III, 1850-1900. *See "Mikawa Manzai."*

62. IVORY. Manzai dancer. 1700-1750.

63. IVORY. Sambaso. Religious dancer. *By* Bizan, 1850-1900. *See "Sambosa."*

64. WALRUS IVORY. Sambaso. *By* Haru Shige, 1750-1800.

65. IVORY. Sambaso. *By* Haru Yuki, 1750-1800.

66. IVORY. Saizo, having imbibed freely at a feast, is using a serving basket as a hand drum. 1850-1900. *See "Maizai."*

67. IVORY. The finding of the child in a peach. *By* Tama Yuki, 1800-1850. *See "Momotaro."*

68. IVORY. Momotaro with his attendants, dog, monkey and pheasant. *By* Tomo Chika, 1800-1850. *See "Momotaro."*

69. IVORY. Monkey in peach. 1700-1750. *See "Momotaro."*

70. IVORY. Monkey. *By* Hogyoku, 1850-1900. *See "Momotaro."*

71. IVORY. Monkey and peach. 1750-1800. *See "Momotaro."*

72. IVORY. Shitakiri Tsuzumi. The departure of old man, laden with box of treasures, for a visit to the sparrow folk. 1850-1900. *See "Shitakiri Tsuzumi."*

73. IVORY. Shitakiri Tsuzumi (tongue-cut sparrow). Departure of old woman with basket from the sparrow folk. *By* Ko Koku, 1850-1900.

74. WOOD. Shishi Mai (Shishi cape and mask, with movable jaw). *By* Miwa, 1800-1850.
See "Shishi Mai."

75. IVORY. Shishi Mai with boy performer. 1750-1800.

76. IVORY, Wood, Lacquer and Shibiyama. Kagura Mai (with movable jaw and ivory boy within) ; the strolling Shishi dancer who drives away evil spirits. *By* Kozan, 1850-1900. *See "Shishi Mai."*

77. IVORY. Shishi Mai performer. 1750-1800.

78. IVORY. Boy—resting after Kagura dance—eating sweet potato. *By* To sai, 1850-1900.

79. WOOD. Strolling Shishi Mai performer. *By* Nyoso, 1850-1900.

80. IVORY. Street acrobat performing Shishi Mai. Shishi cape and mask with movable jaw. 1850-1900.

81. IVORY. Toshi Otoko (Master of Household) performing Oni Yarai. 1850-1900. *See "Oni Yarai."*

82. IVORY. Oni Yarai, New Year household ceremony of casting of black beans through the rooms, by Toshi Otoko (the Master), with invocation driving out the Oni, or evil spirits. *By* Hogyoku, 1850-1900.

83. WOOD. Oni hiding under hat to protect himself from the beans. *By* Sho gyoku, 1850-1900.
See "Oni Yarai."

84. BONE. Shoki, with captured Oni. 1700-1750.
See "Shoki."

85. IVORY. Shoki, the demon destroyer. *By* Masa Haru, 1800-1850.

86. IVORY. Shoki with bag crammed full of Oni. *By* Sada Udji, 1850-1900.

87. IVORY. Shoki the Oni (demon) destroyer.

[11]

88. IVORY. Shoki seizing Oni; another Oni in hiding underneath old hat. *By* Gyoku Yosei, 1800-1850.

89. WOOD AND IVORY. Shoki with captured Oni. 1750-1800.

90. IVORY. Shoki, the demon destroyer, and Oni in attitude of supplication. 1800-1850.

91. IVORY. The Hollander Shoki. 1750-1800.

92. IVORY. Shoki on horseback, with Oni attendants, fording a stream. *By* Hogyoku, 1850-1900.

93. IVORY. Shoki asleep on a Waniguchi (temple drum) being awakened by an Oni; another Oni is hiding in drum. 1850-1900.

94. IVORY. Shoki asleep against empty sake tub, with wine cup on his knee, being tickled by an Oni. *By* Muni Nari, 1850-1900.

95. WOOD. Shoki catching an Oni under hat. 1750-1800.

96. IVORY. Shoki, the Oni destroyer, and his great hat. 1850-1900.

97. IVORY. Shoki's hat on stand and Oni climbing up to secure it. 1800-1850.

98. WOOD. Oni stealing New Year decoration. 1750-1800.

99. IVORY. Oni using a temple censer as a priest chair. *By* Ho Mein, 1850-1900.

100. IVORY. Oni sprite breaking out of clam. *By* Mitsu Yuki, 1850-1900.

101. IVORY. Oni fishing from his shellboat, with fish on line. 1850-1900.

102. IVORY. Oni carrying off tobacco-pouch, pipe-case and netsuke. 1850-1900.

103. IVORY, WOOD AND LACQUER. The effeminate youth, Yemma (Hades god of the Butsu dzo dzui), seated in throne chair, being entertained by Oni beating drum. *By* Gyoku getsu, 1850-1900.
See "Yemma Ten."

104. IVORY AND SHELL. Oni cleaning a Bungaku mask. *By* Kozan, 1850-1900.

105. IVORY. Oni beating a Mokugyo (temple) drum. *By* Shomien, 1850-1900.

106. IVORY. Oni asleep on the drum. 1850-1900.

107. WOOD. Oni looking in steel mirror as he tries to mend one of his horns. *By* Raku Min, 1850-1900.

108. IVORY. Oni No-Nimbutsu (beggar priest as an Oni). *By* Ko Ichi, 1850-1900.

109. IVORY. Fuji Hime (the Goddess of Fuji Yama) serving an Oni with sake. *By* Masa Kadzu, 1850-1900.
See "Fuji Hime."

110. IVORY. Mother Oni playing Kube Hiki, with her baby girl and Chinese boy. *By* O Gyoku, 1850-1900.

111. IVORY. Two Onis repairing the drum of Raiden (God of Thunder). 1850-1900.

112. IVORY. Raiden — the Thunder God — has fallen from the clouds into a tub of water. Shown with drumsticks in hands, and his broken ring of drums. *By* Kigyoku, 1850-1900.

113. IVORY. Oni running off with Hotei's luck bag of treasures. *By* Gyokusai, 1800-1850.

114. IVORY. Oni producing thunder by beating drum in the clouds. *By* Masa Tomo, 1850-1900.

115. IVORY. Kappa ni kiuri. The Kappa and cucumber. 1850-1900.
See "Kappa."

116. WOOD. Kappa with cucumber. *By* Gyo key, 1800-1850.

117. WOOD AND AGATE. Kappa on clam shell. *By* Komin, 1850-1900.

118. BONE. Kappa. 1850-1900.

119. CELADON PORCELAIN. Monkey and peach. 1850-1900. *See* "*Momotaro.*"

120. IVORY. Dharuma as a Hindoo priest. *By* Sei Meen, 1850-1900. *See* "*Dharuma.*"

121. IVORY. Dharuma withstanding the storm. *By* Masa Yuki, 1850-1900.

122. IVORY. Dharuma with Mokugyo, wand, gourd and priest's whisk. *By* Choku sai, 1850-1900.

123. IVORY. Dharuma drinking a cup of sake. *By* Masa tsugu, 1850-1900.

124. CELADON PORCELAIN. Dharuma in mediation. 1750-1800.

125. WOOD. Dharuma in mediation. *By* Riu Kei, 1800-1850.

126. WOOD. Dharuma. *By* Min Koku, 1850-1900.

127. WOOD. Dharuma in mediation. *By* Shumin, 1850-1900.

128. BIZEN STONEWARE AND LACQUER. Dharuma disturbed in his meditation. 1800-1850.

129. IVORY. Benkei as Dharuma. 1800-1850.
 See "*Benkei.*"

130. IVORY. Spirit of Dharuma rising from a Mokugyo (temple wooden drum). *By* Ryusai, 1850-1900.

131. IVORY. Meditative Dharuma disturbed by spider. *By* Choku sai, 1850-1900.

132. IVORY. Uzume (Goddess of Mirth) as meditative Dharuma. 1800-1850.

133. IVORY. Dharuma yawning — Buddhist whisk in front. *By* Hidey Masa, 1800-1850.

134. WOOD Lacquered. Dharuma. *By* Yuso, 1800-1850.

135. IVORY. Frolicking Dharuma elves. 1850-1900.

136. WOOD. Dikoku (the God of Wealth and Prosperity) making a prisoner of poverty; shown tying up a ragged beggar. *By* Min ko, 1800-1850.

137. WOOD. Tanuki (badger), moon-gazing and beating his "drum" stomach. *By* Shige Chika, 1850-1900.

138. IVORY. The badger pot. *By* Masa Nao III, 1850-1900. *See "Bumbuku Chagama."*

139. WOOD. Tadanobu, the fox man, with Shizuka's Tsuzumi (drum). *By* Itan Sai. 1800-1850.
See "Shizuka."

140. IVORY. Badger wearing farmer's hat and carrying bottle of sake, standing on his own distended scrotum; base forming a seal. 1850-1900.

141. WOOD. Badger as Buddhist priest, with whisk in hand. *By* Kuni Mitsu, 1850-1900.

142. WOOD. Kosen Sei—Gama Seneen (Frog Saint). *By* Toyo Kadzu, 1750-1800.

143. IVORY. Kosen Sei—Gama Seneen (Frog Saint). 1700-1750.

144. IVORY. Mammoth frog with Oni. 1650-1700.

145. WOOD. Gama Seneen watching the frogs wrestling. *By* Hozan, 1700-1750.

146. IVORY. Gama Seneen with frog. 1650-1700.

147. BLACK HINO KI WOOD. Gama Seneen. *By* Ki Riu, 1700-1750.

148. IVORY. Kintaro with frog, watching frogs wrestling. *By* Tomo Yuki, 1850-1900. *See "Kintaro."*

149. IVORY. Birth of the Tengu (Mountain God's attendant). *By* Ga Raku, 1850-1900. *See "Tengu."*

150. IVORY. Tengu (Mountain God) in the egg, covered with fallen leaves. *By* Gyoku ey, 1850-1900.

151. WOOD. The Tengu grinding beans in a mortar and using his nose beak as a pestle. 1700-1750.
See "Tengu."

152. IVORY. Shojo (Wine Goddess) with wine jar, ladle and wine cup. 1850-1900. *See "Shojo."*

153. IVORY. Shojo with dipper. *By* Raku Min, 1850-1900.

154. WOOD. Shojo (Wine God) in attitude of Suzume O Dori (sparrow dancer), with wine cup as hat. *By* Masa Kadzu, 1850-1900.

155. WOOD. Shojo (Wine Goddess) asleep. *By* Masa Maru, 1800-1850.

156. WOOD, Ivory and Lacquer with Inlays. The No Dancer—Shojo. *By* Tomo Kadzu, 1850-1900.

157. IVORY. Ashi Naga and Tey Naga, the long-legged and long-armed companions, returning from fishing. *By* Minkoku, 1850-1900.

158. IVORY. Ashi Naga, the long-legged man, playing samisen and singing. *By* Min Koku, 1850-1900.

159. IVORY and Bronze. Niyo and Jizo wrestling on lotus leaf. *By* Ichi Mei, 1850-1900.

160. IVORY. Diving girl and octopus. *By* Yokuga sai, 1850-1900.

161. WOOD. Blind masseur at work. *By* Etsu Min, 1800-1850.

162. IVORY. Reading letter. *By* So Ichi, 1850-1900.

163. WOOD. Grass cutter fallen asleep on large palm leaf. 1850-1900.

164. IVORY. "One butterfly between two chicks." *By* Sho Gyoku, 1850-1900.

165. IVORY. Octopus attacking monkey. *By* Tomo Ma-sa, 1850-1900.

166. IVORY. Monkey entrapping octopus under bean meal bowl. *By* Koga, 1850-1900.

167. WOOD. Monkey carrying large mushroom. 1750-1800.

168. BOX WOOD. "The flea hunt by mother monkey." *By* Suki Naga, 1750-1800.

169. IVORY. Three monkeys—father and two babies. 1700-1750.

170. BOX WOOD. Three monkeys. "There is none more deaf than he who won't hear; none more dumb than he who won't speak; none more blind than he who won't see." *By* Shugetsu. 1800-1850.

171. IVORY. Monkey trainer and companion resting at a roadside tea-stall for a quiet smoke. *By* Gyok ko, 1850-1900.

172. IVORY. Vampire on two roof tiles. 1850-1900.

173. IVORY. Showman's monkey on fan. 1800-1850.

174. IVORY. Showman's monkey with hobby-horse. 1750-1800.

175. IVORY. Mother monkey reclining on a bed of leaves protecting her sleeping babe. 1800-1850.

176. IVORY. Saru no Manzai (the manzai monkey). *By* Min Koku, 1850-1900. *See* "*Manzai.*"

177. IVORY. Monkey and persimmon (Saru Kani Kassen). Story of the monkey and the crab. *By* Ichi Gyoku, 1850-1900.

178. KIRI GANE (Chipped Gold) LACQUER. Mother and baby monkey. 1850-1900.

179. IVORY. The Spy, Onchi Sakon, disguised as a monkey showman. 1850-1900. *See "Onchi Sakon."*

180. IVORY. Sleeping monkey in peach. 1650-1700.
See "Momotaro."

181. IVORY. Cat on an abalone. 1700-1750.

182. IVORY. European dog and puppy. 1800-1850.

183. IVORY. Japanese puppy. 1750-1800.

184. IVORY. Dog with ball on neck. 1700-1750.

185. IVORY. Dog with tama, or ball. Study of a foreign or Holland dog. 1700-1750.

186. IVORY. Dog and drum. 1650-1700.

187. IVORY. Takaramono. Dog on bag-of-plenty. 1700-1750.

188. WOOD. Dog with movable collar. 1750-1800.

189. WOOD. Made in Nara. Shojo No Dancer. 1700-1750.

190. WOOD. Made in Nara. Coloring almost obliterated. Okami—Goddess of Pleasure. 1650-1700.

191. WOOD. Nara coloring. The two household gods, Yebisu and Dikoku, carrying their goddess, Benten, in a kago. 1850-1900.

192. IVORY. Dog. (Sign of Zodiac.) *By* Oka nobu. 1850-1900.

193. IVORY. Snake coiled. (Sign of Zodiac.) *By* Shoji, 1800-1850.

194. WOOD. Dragon. (Sign of Zodiac.) *By* Tomo Chi-ka, 1800-1850.

195. IVORY. Horse. (Sign of Zodiac.) 1700-1750.

196. IVORY. White rabbit. (Sign of Zodiac.) 1750-1800.

197. IVORY. Wild boar. (Sign of Zodiac.) 1850-1900.

198. IVORY. Tiger (Sign of Zodiac.) *By* Ta guchi, 1800-1850.

199. IVORY. Rat. (Sign of Zodiac.) 1850-1900.

200. WOOD. Goat. (Sign of Zodiac.) *By* Ko Key, 1800-1850.

201. IVORY. Bull. (Sign of Zodiac.) 1750-1800.

202. IVORY. Monkey. (Sign of Zodiac.) 1750-1800.

203. WOOD. Rooster. (Sign of Zodiac.) 1750-1800.

204. IVORY. Old man crossing rock bridge and mussel-gathering boy handing him his sake gourd. *By* Masa Tsugu, 1850-1900.

205. IVORY. Niyo (emblem of strength). *By* Ho Gyo-ku, 1850-1900.

206. IVORY. Landscape in clam shell. *By* Shogetsu, 1750-1800.

207. IVORY. Children caught in clam. *By* Gyoku Zan, 1850-1900.

208. IVORY. "The clam's dream." (Clam shell with spirit cloud rising from it.) The shell is formed from a lotus leaf. *By* Hidey Masa, 1800-1850.

209. WOOD. The eel-house cook struggling with an eel. *By* Nyoso, 1850-1900.

210. IVORY. The cook struggling with an eel. *By* Nyo-so, 1850-1900.

[19]

211. WOOD. "The considerate son." Stopping to re-tie
his loosened sandal whilst bringing home his
father's sake bottle, he holds it by the cord in his
mouth that the bottle may not be fouled by con-
tact with the earth. *By* Raku Min, 1850-1900.

212. IVORY. The fencing bout. *By* Cho ku sai, 1850-
1900.

213. WOOD. Miller trying to catch rat with a Masu
(rice measure). 1800-1850.

214. WOOD. Miller trying to catch rat under rice meas-
ure. *By* Masa Atsu, 1850-1900.

215. IVORY. Adachigahara trying to slaughter young
mother. *By* Gyokusei, 1800-1850.
See "Adachigahara."

216. IVORY. The saint Shoshi and his attendant, the
dragon, rising from the fumes of the censer. 1700-
1750.

217. IVORY. The saint Shoshi holding censer, from the
fumes of which rises his attendant, the dragon.
By Nobi, 1700-1750.

218. IVORY. Tobosaku and peach—emblem of longev-
ity. 1700-1750. *See "Tobosaku."*

219. WOOD. Kwanyu (deified Chinese general) seated
on horse. 1650-1700.

220. IVORY. Suzumi O Dori (sparrow dance). 1800-
1850.

221. IVORY. Tada Mori meeting the Gi Yon Ji lantern
lighter. *By* Gyoku Shu, 1850-1900.
See "Tada Mori."

222. IVORY. Child and man playing horse. *By* Ho Gyo-
ku, 1850-1900.

223. IVORY. Horse. 1750-1800.

224. IVORY. Tamai ya, a street vender of bamboo pipes and juice for soap bubbles. *By* Do Raku, 1850-1900.

225. IVORY. O Saru San (girl's rag doll), with Suzu (shrine bell), Takara mono design on dress. *By* Ga Raku, 1850-1900.

226. IVORY. Saishi (one of the twenty-four paragons of filial virtue) nursing her grandmother, who was incapable of eating solid food. *By* Masa Yuki, 1850-1900.

227. IVORY. The Goddess Benten and attendant. *By* Tomo Chika, 1800-1850.

228. BOX WOOD. A tiger (after Chinese) licking his paw. *By* Suki Yuki, 1800-1850.

229. IVORY. Imaginary tigers. *By* Ho uhn sei Kwa Tey, 1750-1800.

230. BOX WOOD. Semi-conventionalized tiger in repose. 1700-1750.

231. IVORY. Man resting whilst receiving massage treatment from boy Ama. *By* Ho Gyoku, 1850-1900.

232. IVORY. Dragon. 1800-1850.

233. IVORY. Hachiman, a god of war. *By* Choku sai, 1850-1900.

234. IVORY. Boy with bamboo gun and fox mask. *By* Ho Ichi, 1850-1900.

235. IVORY. A samurai in ceremonial dress, with an attendant, about to cut up the living tai (fish). *By* Jiu Gyoku, 1850-1900.

236. IVORY. Ushiwaka (the hero Yoshitsune as a youth cutting up an enormous carp). *By* Ho Ichi, 1850-1900.　　　　　　　　　　*See "Yoshitsune."*

237. IVORY. Yaki Dango vender broiling his spitted sweet rice-cakes for the children. *By* Kio min. 1850-1900.

238. IVORY. Fox witch on lotus leaf. 1800-1850.

239. IVORY. Ghost stealing a grave stake. 1850-1900.

240. WOOD. Child seeing his tongue in a polished metal mirror. *By* So Kiu, 1850-1900.

241. IVORY. Man grinding beans in Ishi Usu (two grinding stones). *By* Masa Tsungu, 1850-1900.

242. IVORY. The delivery boy stopping on the wayside for a shell-fish feast (Sazai no Tsubo Yaki). *By* Toshi ichi, 1850-1900.

243. BOX WOOD. Deer. *By* Kan sen, 1750-1800.

244. IVORY. Old man pulling leech from cheek—toothache remedy. *By* Gyoku zan, 1850-1900.

245. IVORY AND WOOD. Nana Kusa, a household spring ceremony. The seven green herbs being chopped by the master in ceremonial costume and cooked on the seventh day of the first month as a charm against diseases. *By* Sho Gyoku, 1850-1900.

246. IVORY. Tako Bodzu (the priest octopus). *By* Cho Ku Sai, 1850-1900.

247. IVORY, LACQUER AND METAL. Man cutting his toe nails. Hat and dress of Nashiji lacquer and minute shibiyama (inlays). 1900.

248. IVORY. Girl washing her hair. *By* Gyoku zan, 1850-1900.

249. WOOD. Woman clam gatherer with child. *By* Jiu Gyoku, 1850-1900.

250. IVORY. "A quiet smoke." Traveler resting on roadside with hat for cushion. 1850-1900.

251. WOOD. Wasp in Nashi (native pear). *By* Kogetsu, 1850-1900.

252. IVORY. Spotted deer and monkey. 1750-1800.

253. BONE. Oni No Nimbutsu, beggar pilgrim priest depicted as Oni. 1850-1900.

254. IVORY. Girl killing monkey. *By* Gyoku Sai, 1800-1850. *See "Filial Devotion."*

255. IVORY. Hairy-tailed turtle (emblem of longevity) on flat rock. 1800-1850.

256. IVORY. Sage and scroll. 1700-1750.

257. IVORY. Performer of Okagura, a Shinto dance, shown with mask and gohei staff in hand. *By* Gyokko, 1850-1900.

258. IVORY and Wood. Sacred white fox with stick of Shinto gohei. 1800-1850.

259. WALRUS IVORY. Shoki with two quarreling Oni. 1850-1900.

260. WOOD. Confucius in his youth saving his playmate by breaking porcelain water jar with stone. *By* Miwa, 1800-1850.

261. IVORY. Rat eating chestnuts. *By* Ran Sen, 1800-1850.

262. IVORY. Shoki. 1800-1850.

263. IVORY. Nuke Kubi (long-necked man) and child. *By* Hog Yoku, 1850-1900.

264. IVORY. Kama Arai (cleaning the rice kettle). 1750-1800.

265. IVORY. Tanuki Bozu (badger goblin) licking sake bottle. *By* Yomin, 1850-1900.

266. OMO ROGI (petrified wood). Spider. 1800-1850.

267. IVORY. Mushrooms, chrysanthemum and frog. *By* Saza nami, 1850-1900.

268. BONE. Lotus leaf and frog. *By* Tani, 1800-1850.

269. IVORY. Rat and chestnut. 1700-1750.

270. IVORY. Sleeping tortoise. 1750-1800.

271. IVORY. Monkey and Katsuyu goat, curiously drawn with curved forelegs. 1700-1750.

272. IVORY. Two wrestlers. The arm and foot throw. 1800-1850.

273. WOOD. Lotus seed pod with movable seeds. 1800-1850.

274. WALRUS IVORY. Four persimmons and snail. 1650-1700.

275. IVORY. The Seneen Oshikio and resting bull. 1650-1700.

276. IVORY. Monkey; ball-balancing performer. *By* Shun Zan, 1850-1900.

277. IVORY. Man poling raft of logs upstream, provisions wrapped in bundle. *By* Tomo Kuni, 1850-1900.

278. IVORY. Asa Hina Saburo and Oni. 1700-1750.
See "Asa Hina Saburo."

279. WOOD. Man yawning. 1700-1750.

280. IVORY. Baka Biashi (two Shinto No dancers). *By* Ho Meen, 1850-1900.

281. WOOD. In form of Kashira (sword end) chrysanthemums. 1850-1900.

282. IVORY. The Sea King Riu Jin of the Gigaku No dance. *By* Ho ichi. 1850-1900.

283. TSUI TSHI (Cinnabar Lacquer). In Kobako (toilet box) form. 1750-1800.

284. IVORY. Seneen in meditation. 1700-1750.

285. IVORY. No dancer. *By* So Ichi, 1850-1900.

286. WOOD. The sleeping mermaid. 1750-1800.

287. IVORY. Sotoba Komachi. Komachi seated on a fall-en grave-post. *By* Masa Kadzu, 1850-1900.
See "Komachi."

288. IVORY. Two wrestlers and umpire. *By* Ghoku Ho, 1850-1900.

289. IVORY. Fukuru Tsuzumi, lucky baby sparrow. *By* Genko, 1700-1750.

290. WOOD. Man trying to raise himself by his legs. 1750-1800.

291. AGATE WITH MATRIX. Chestnut and peanuts. 1700-1750.

292. IVORY. Red beans, "mouse nibbled." 1850-1900.

293. IVORY. Hetchima (vegetable sponge gourd) with frog. *By* Haru Kadzu, 1850-1900.

294. IVORY. Icho nuts. *By* Oka Tomo, 1800-1850.

295. IVORY. Biwa (Loquot) fruit. *By* Mitsu Hiro, 1800-1850.

296. IVORY. Eggplants. Signficant of good-luck dreams. 1800-1850.

297. IVORY. Three beans. *By* Naga tsune, 1800-1850.

298. IVORY. Two mushrooms. 1750-1800.

299. IVORY. Mushroom and chestnut. *By* Mitsu Hiro, 1800-1850.

300. WOOD. Three chestnuts. 1800-1850.

301. WOOD. Mushroom and chestnut. 1850-1900.

302. IVORY. Deer. *By* Ran ichi, 1750-1800.

[25]

303. IVORY. Chinese sage. 1700-1750.

304. WOOD AND LACQUER. Deadwood branch with vine in green lacquer, wasp, and lady bug in metal and lacquer. 1850-1900.

305. IVORY. The Chinese Priest Keishi. 1700-1750.

306. IVORY. A Hollander. 1650-1700.

307. IVORY. Man and child with drum. *By* Kozan, 1850-1900.

308. IVORY. Man with masu (rice measure) in hand, standing beside Kome tsuki, rice threshing vessel with pounding mallet. *By* Rio Zan, 1850-1900.

309. WOOD. A wrestler, empty sake bottle in hand, licking the wine cup. 1700-1750.

310. IVORY. Hollander carrying child on his back in Japanese fashion. *By* San Ka, 1700-1750.

311. IVORY. Night before the battle. Two warriors of the Watanabe family, one shaving, other writing home. Base shows camp enclosure. *By* Gyokusai, 1800-1850.

312. IVORY. Buddhist acolyte desecrating the temple belongings, warming himself over the censer. *By* Choku sai, 1850-1900.

313. IVORY. Rat disturbed by cat at its wax feast within a hand lantern. *By* Sho meen, 1850-1900.

314. IVORY. Rat eating the candle grease on lantern. 1850-1900.

315. WALRUS IVORY. Frog carrying small frogs in lotus leaf. *By* Gyoku sen, 1850-1900.

316. WOOD. Two frogs on waraji (straw shoe). *By* Masa Nao, 1800-1850.

317. IVORY. Lotus leaf and three frogs. 1800-1850.

318. IVORY. Seven frogs on an old waraji (straw sandal). 1850-1900.

319. WOOD. Two frogs. *By* Tomo Chika, 1800-1850.

320. WOOD. Frog on old well bucket. *By* Masa Nao III, 1850-1900.

321. WOOD. A strolling minstrel's "chobu kure" (hand drums). 1800-1850.

322. IVORY. Mokug yo (temple drum) with frog. 1850-1900.

323. WOOD. Mokugyo (temple drum), lacquered and studded with jewels. *By* Yuso, 1750-1800.

324. IVORY. Mokugyo (temple drum). 1850-1900.

325. SILVER, GOLD, SHAKUDO AND GORORSA BRONZES. Bucket, ladle, stirrup and horse bit. 1800-1850.

326. IVORY. Badger and dog desecrating disinterred tub coffin. 1800-1850.

327. IVORY. A youthful test of Jiu jitsu. *By* Masa fume, 1850-1900.

328. WOOD TAGA YA SAN. Gourd vine in coral, jade and pearl shell. 1800-1850.

329. FISHBONE. Section of dried salmon. 1850-1900.

330. WOOD AND IVORY INLAYS. The decorated Mochi (New Year) cakes on wood stand. 1850-1900.

331. WOOD, IVORY, SHELL AND METAL. Metal bound wooden tray of shellfish. *By* Shin Mey, 1850-1900.

332. IVORY. Nana Kusa, ceremony of preparing the seven green herbs as charms against diseases; shown with chopper and pot for cooking. 1700-1750.

333. WOOD. The three phases of intoxication—mirth, anger and sorrow. *By* Naga tsugu, 1750-1800.

334. IVORY, Elephant Tooth. Kitsuni (fox). *By* Ga Raku, 1850-1900.

335. IVORY. Sambo kojin family traveling — mother and children on horseback. *By* Gyoku tani, 1850-1900.

336. WOOD, Ivory, Lacquer, Porcelain and Gold. Large open book with smokers' brazier, tobacco pouch and pipe case (in Guri lacquer); ojime (in porcelain), ivory Manju Netsuki and gold pipe. Reverse, book-cover entitled "Noted Battles." 1800-1850.

337. IVORY. Boy Momotaro with Tengu-shaped monkey mask. 1700-1750.
See "Momotaro" and "Tengu."

338. WOOD. Shiyei Sennin (Saint) riding to heaven on the carp. 1700-1750. *See "Shiyei."*

339. IVORY. Bear cubs wrestling. 1800-1850.

340. IVORY. Fish, squid, abalones and oyster. *By* Ippo. 1800-1850.

341. LACQUER in Gold and Vari-colors. "The setting stork"—Kobako (incense box) form, lined with Kiri Kane Make (gold chipped lacquer). 1850-1900.

342. IVORY. Pillow-shape design—children's toys. *By* Ho ichi, 1850-1900.

343. WOOD. Badger with distended scrotum smothering a hunter. *By* Itan sai, 1800-1850.

344. IVORY. The learned child reading poem to the servant. *By* Chiku Yo sai, 1800-1850.

345. WOOD. The quarrel. *By* Minko, 1800-1850.

346. WOOD. Strolling minstrel with Mokugyo. 1800-1850.

347. IVORY. The good Buddhist and the wolf. 1800-1850.

348. WOOD. The Kappore dance by hilarious guest. *By* Masa Nao I, 1750-1800.

349. IVORY. Sho Chiku Bei, three turtles inside. *By* Tani, 1800-1850. *See "Sho Chiku Bei."*

350. WOOD. Chinese farmer, wife and child. *By* Tomo Taka, 1850-1900.

351. WOOD AND IVORY. Woman Dharuma. 1850-1900.

352. IVORY. Kitsuni O Dori (the fox dance). *By* Ichi Mura, 1750-1800.

353. WOOD. Man polishing stone. *By* Tomo masa, 1850-1900.

354. IVORY. Monkey leaning over sleeping farmer. 1800-1850. *See "Filial Devotion."*

355. IVORY. A good Buddhist (rosary on ear), returning late, is welcomed by his dog. *By* Rio Min, 1850-1900.

356. IVORY. Chinese sage. 1750-1800.

357. IVORY. Zato blind biwa player, crawling. *By* Hikaku, 1850-1900.

358. IVORY. Two Shishi playing. 1850-1900.
 See "Shishi."

359. WOOD. Shishi with his tama. *By* Masa Yoshi, 1800-1850.

360. IVORY. Three children with Shishi mask and drum. 1750-1800. *See "Shishi Mai."*

361. IVORY. Shishi. 1700-1750.

362. BRONZE. Kara Shishi. 1700-1750.

363. IVORY. Shishi. 1850-1900.

364. IVORY. Crouching Shishi. 1700-1750.

365. WOOD. Shishi on Mokugyo. 1750-1800.

366. IVORY. Shishi. Shows Egyptian influence. 1600-1650.

367. IVORY. Shishi and tama. *By* Yu Kan, 1850-1900.

368. BAMBOO. Kara Shishi. *By* Ito, 1750-1800.

369. IVORY. Recumbent Shishi with boy on back. 1700-1750.

370. IVORY. Shishi—Koro form. 1850-1900.

371. IVORY. Baku Shishi—a mythical animal which feeds on bad dreams. 1750-1800.

372. IVORY. Hakutaku Shishi with tama. 1850-1900.

373. IVORY. Shishi. 1800-1850.

374. IVORY. Shishi. 1700-1750.

375. IVORY. Shishi. 1650-1700.

376. WOOD. Kara Shishi with tama in mouth. 1750-1800.

377. IVORY. Shishi. 1700-1750.

378. IVORY. Shishi. 1700-1750.

379. IVORY. Shishi with young (tiger tailed). 1650-1700.

380. WOOD, RED LACQUERED. Kara Shishi with ball case. 1700-1750.

381. IVORY. Shishi (reversed head) looking backwards. *By* Masa Ji, 1750-1800.

382. IVORY. Shishi. 1750-1800.

383. IVORY. Shishi. 1700-1750.

384. IVORY. Shishi. 1650-1700.

385. IVORY. Shishi. 1650-1700.

386. IVORY. Shishi. 1750-1800.

387. IVORY. Shishi. *By* Tomotada, 1750-1800.

388. IVORY. Shishi. 1650-1700.

389. IVORY. Group of five Shishi and peony. 1850-1900.

390. IVORY. A crouching (dog formed) Shishi. 1700-1750.

391. IVORY. Stotsu Mey Kozo—one-eyed boy ghost. 1850-1900.

392. IVORY. War camp watchman with wood clappers. *By* Tomo Chika, 1800-1850.

393. IVORY. Chinese sage and child. *By* Masa tada, 1800-1850.

394. BONE. Burnt wax candle with paper wick. 1700-1750.

395. IVORY. Moso carrying great bamboo shoot. *By* Sho Sai, 1900. *See "Moso."*

396. IVORY. Youth carrying edible octopus followed by dog. *By* Somin, 1850-1900.

397. IVORY. Hare. *By* Toyo Masa, 1800-1850.

398. IVORY. One of the "Tennin," Buddhist musical goddess. 1850-1900.

399. IVORY. Sea dragon. 1750-1800.

400. IVORY. Tennin, Buddhist musical goddess. 1850-1900.

401. IVORY. Kumoski, with household pestle and mortar, making toro ro. *By* Do Raku Sai, 1850-1900.

402. IVORY. Ashinaga with bird perched on his knees. *By* Gyokudo, 1800-1850.

403. IVORY. Boy asleep over writing table, with scroll, brush and ink case. *By* Mitsu Masa, 1850-1900.

404. IVORY. Sage writing character for happiness. *By* Gyomeen, 1850-1900.

405. IVORY. Karako (child) with Chinese Fukuroku jin reclining on arm rest. *By* Toyo masa, 1800-1850.

406. IVORY. The Sennin "Kiku jido." 1650-1700.

407. IVORY. Komuso, strolling ronin minstrel. *By* Komin, 1850-1900.

408. IVORY. The flight of Tokiwa with her three sons —"Yoritomo" (the eldest, who became the first shogun), "Otawaka" and "Yoshisune" (babe in arms). *By* Riu Mon, 1850-1900.
See "Yoshitsune."

409. IVORY. Conventionalized Shishi head. 1700-1750.

410. SHAKUDO BRONZE. Shoki, Oni on reverse. *By* Shu Raku, 1800-1850.

411. IVORY. Tortoise, leaves and water spray. 1750-1800.

412. IVORY. Hornet (in Shibiyama) on a persimmon. 1750-1800.

413. IVORY. Urashima Taro. The moment of opening the box. 1800-1850. *See "Urashima."*

414. IVORY. Manju form. Two Shishi and peony. 1700-1750.

415. IVORY. Child with turtle. Reverse, double peach and flower. 1800-1850.

416. IVORY. Square Manju. Three No Masks—Tengu, Hannya, and Heida. *By* Ko Shu, 1750-1800.

417. IVORY. Oval Manju form. House, bamboo grove and inserts of flying sparrows in silver and copper. Bronze reverse, bamboo and hoe. 1850-1900.
See "Shita Kiri Tsuzume."

418. WOOD AND IVORY. Manju form. *By* Gyoku Ichi, 1750-1800.

419. IVORY. Oval Manju. "Fujiyama in the clouds." Insert, Mountain of Umi Matsu (sea pine) ; clouds of green stone. 1700-1750.

420. IVORY. Oblong Manju, Dharuma burning incense. *By* Shi Jun, 1750-1800.

421. IVORY. Manju, Mikawa Manzai; reverse, all their attendant appurtenances. *By* Gyoku ho sai, 1800-1850.

422. IVORY. Oval Manju, conventionalized newt. 1750-1800.

423. SHELL, Lacquer and Metals. A Samurai in Shibooichi and Shakudo bronzes, gold and silver. 1800-1850.

424. IVORY. Manju, sea dragon. 1750-1800.

425. IVORY. Shishi and peony. 1750-1800.

426. IVORY. Chrysanthemum and bird. 1750-1800.

427. CLOISONNE on Copper. Manju. 1800-1850.

428. LACQUERED WOOD. Manju. Conventional flower design in Nuri Shippo (lacquer cloisonne). 1800-1850.

429. SILVER AND BRONZE. Manju. Hoo birds and flowers in Shippo (enamel) ; Dutch influence. 1700-1750.

430. TSUI TSHI (cinnabar lacquer). Manju. Shishi; reverse, peonies. 1800-1850.

431. LACQUER. Manju. Bumbuku Chagama, the iron kettle transforming into a badger. 1800-1850.
See "Bumbuku Chagama."

432. WOOD. Manju. Shibiyama inlay. A samurai shown seated in ceremonial dress with sword—"head," cherry blossoms; "dress," leaves; "sword," a branch. "The life of a samurai is likened to the bloom of a cherry tree." 1800-1850.

433. SILVER, HAMMERED. Dragon in clouds. *By* Kiku Garu, 1800-1850.

434. SENTOKU BRONZE, CASTING. Shell, with conventionalized sea spray. 1750-1800.

435. BRONZE. Manju. Plaited ribbons of Shakudo and Suaka bronzes. 1750-1800.

436. IRON. Oval Manju. Inlays of bronzes and silver. Viewing the waterfall by moonlight. 1650-1700.

437. IRON. Manju, with gold and silver zogan. Wild flowers and grasses by moonlight. 1750-1800.

438. IRON. Manju, with gold zogan (damascene). 1750-1800.

439. CAST IRON. Manju: obverse, landscape; reverse, gourd vine. 1700-1750.

440. WOOD. Manju, with flying stork of hammered silver. 1700-1750.

441. WOOD. Manju. Nine masks. 1800-1850.

442. DEER HORN. Manju. Tako (an octopus) conventionalized. 1800-1850.

443. IVORY. Manju. Sickle, ring and character. "Sickle," Kama; "ring," Wa; "character," Nu. "Kama wa nu" (nothing troubles me). 1800-1850.

444. WALRUS IVORY. Manju. Grapes on trellis work. 1750-1800.

445. IVORY. Manju. Conventionalized combination of stork and Hoo birds with clouds, and crest of Goto family. 1750-1800.

446. IVORY. Manju. Pine tree and ivy. 1800-1850.

447. IVORY. Manju. Takaramono—emblems of good luck. 1800-1850. *See "Takaramono."*

448. IVORY. Manju. Leaves. 1800-1850.

449. IVORY. Manju. Fret work. 1800-1850.

450. IVORY. Manju. Flying geese and maples. "Inconstancy." 1800-1850.

451. IVORY. Manju. Newt and dog Fo. 1800-1850.
 See "Shishi."

452. IVORY. Manju. Falcon and pine. 1800-1850.

453. IVORY. Manju. Swallows and willow scroll. 1800-1850.

454. IVORY. Manju. A Hanashika (public story-teller). 1750-1800.

455. IVORY. Manju. Chrysanthemum and water. 1850-1900.

456. IVORY. Manju. Maple leaves and water. 1800-1850.

457. IVORY. Manju. Two newt. *By* Ho ichi, 1850-1900.

458. IVORY. Manju. Raiden (Thunder God), with his broken ring of drums, falling into the sea; a crab has caught him by the leg with one of its claws and with another is holding one of Raiden's drumsticks. *By* To Sho Sai, 1750-1800.

459. IVORY, OPENWORK. Manju. Lotus leaf flower and pod. 1850-1900.

460. IVORY. Manju. Rooster on drum, pine tree and vine. 1800-1850.

461. IVORY. Manju. Kintaro overcoming the serpent. 1850-1900. *See "Kintaro."*

462. IVORY. Manju. Hoo and peony. 1800-1850.

463. IVORY. Manju. Boy studying song. *By* Ichi Yu, 1850-1900.

464. IVORY. Manju. Sho Chiku bei in "Mon" form. 1800-1850. *See "Sho Chiku Bei."*

465. IVORY. Manju. Six masks. 1800-1850.

466. BONE. Manju. All the Takaro mono (lucky emblems). *By* To Koku, 1850-1900.
 See "Takara Mono."

467. IVORY. Manju. Dharuma. 1700-1750.

468. IVORY. Manju. Dikoku's mallet of prosperity and the destructive rats. 1750-1800.
 See "Sthi Fuku Jin."

469. IVORY. Manju. Flowers — chrysanthemums and peonies. 1800-1850.

470. IVORY. Manju. Basket-fence and snail. Itcho and maple leaves with three roof tiles. Poetic emblems. 1750-1800.

471. IVORY. Manju. Expressing "Akumbei"—"See any green in my eye?" 1850-1900.·

472. IVORY. Manju. Bin zuru (one of the sixteen disciples of Shaka). *By* Mitsu Toshi, 1850-1900.

473. IVORY. Manju. Conventionalized newt and waves. 1800-1850.

474. IVORY. Manju. Oni discovering feast prepared for Hotei and Yebisu. 1800-1850.
 See "Sthi Fuku Jin."

475. IVORY. Manju. Ten-petaled Kiku Mon. 1800-1850.

476. WALRUS IVORY. Manju. Ten Jiku (Hindoo) fisherman and conventional skate and waves. 1700-1750.

477. IVORY. Manju. Emblems of the principal fete days of the year. 1750-1800.

478. IVORY. Manju. Man holding his tongue. 1800-1850.

479. IVORY AND SHIBIYAMA. Manju, with human bone pin. Cherry tree with a few flowers; priests' (money) bowl for offerings; skull and gravestakes. Reverse, Buddhist rosary. "The briefness of life is like the blossoming cherry. Beauty and wealth in life are lost in death. Such are the teachings of Buddha." By Shibiyama Masa Nao, 1800-1850.

480. BONE. Manju. Hermit priest breaking through window. 1800-1850.

481. IVORY. Manju. Semi-conventionalized elephant-mermaid and waves. Reverse, Mannen taki (Fungi). 1750-1800.

482. IVORY. Manju. Two children rolling snowball. Reverse, Fujiyama and rabbit. By Cho ko sai Rui Mey, 1800-1850.

483. IVORY. Manju. Dharuma in meditation with whisk in hand. Reverse, scroll, lotus and cloud-swirl. 1850-1900.

484. IVORY. Manju, square. Ebisu struggling with a great Tai (fish). "The enormity of life's struggle for food."

485. IVORY. Manju. Rice culture (in Shibiyama, and metal inlay) hoe, scarecrow hat, sparrow, and rice in seed. By Shibiyama I, 1750-1800.

See "Shibiyama."

486. IVORY. Manju. Peony and maples. Side insert, for cord attachment, of bronze Shishi. 1750-1800.

487. IVORY. Manju. Peony flowers (in color) with insert of Shishi in gold. 1800-1850.

488. IVORY. Manju. Willow tree (in Shibiyama inlay). Oni mending Shoki's Geta, or shoe (in Gorossa bronze). 1800-1850.

489. IVORY AND SILVER. Manju. Lotus leaf and flower with stakes, on bank of stream. 1850-1900.

490. IVORY AND SILVER. Manju. Hyena with old hat, pine tree and bamboo. *By* Tani, 1800-1850.

491. IVORY AND SILVER. Manju. Quail and millet. *By* Ko, 1800-1850.

492. IVORY AND METAL. Manju. Mother Kappa (under willow tree on bank of stream) fishing with rod. Child Kappa fishing with hand-net. 1750-1800. *See "Kappa."*

493. IVORY. Manju. Boy child. Reverse, cinnabar lacquered Tai (fish) toy. *By* Ju Gyoko, 1800-1850.

494. IVORY. Manju. Dharuma in his hermitage. *By* Ko Ren, 1800-1850. *See "Dharuma."*

495. IVORY. Manju. Woman with mortar and pestle preparing "To-ro-ro." *By* Ichi Yusei, 1850-1900.

496. IVORY. Manju. Hotei, with his bag of gifts, asleep in a boat. *By* Suzuki Kosai, 1850-1900.
See "Sthi Fuku Jin."

497. IVORY. Manju. Child and mask. *By* Ho Meen, 1850-1900.

498. IVORY. Manju. Ben kei reading from subscription list before Sayemon. *By* Gyoku Yu, 1800-1850.
See "Benkei."

499. IVORY. Manju. Willow and swallow. Reverse, bamboo and sparrow. *By* Mitsu Hiru, 1800-1850.

500. IVORY. Manju. Flower and some conventionalized clouds. *By* Toshi tsugu, 1800-1850.

501. IVORY. Manju. Yoshitsune as a boy, then known as Ushiwaka, struggling with immense carp. *By* Shun Yei, 1800-1850. *See "Yoshitsune."*

502. IVORY. Manju. The finding of Momotaro (the peachling). *By* Mori Tsugu, 1800-1850.
See "Momotaro."

503. IVORY. Manju. Child returning from street fete. *By* Hogyoku, 1850-1900.

504. IVORY. Manju. Futun (God of Wind), with his bag. *By* Kouhn, 1850-1900.

505. IVORY. Manju. Toy maker painting Dharuma toys. 1800-1850. *See "Dharuma."*

506. IVORY. Manju. Bird, peach and flowers in Shibi-yama inlay. *By* Riu Riu sai, 1800-1850.

507. IVORY. Manju. Chinese child and hobby-horse. *By* Kaku yu sai, 1800-1850.

508. BONE. Manju. Karako (happy child). Reverse, peony and butterfly. 1800-1850.

509. IVORY. Manju. Okami, the Goddess of Pleasure and Happiness, performing the ceremony of Oni Yarai on New Year's Eve—driving out the Oni (evil spirits) by the casting of dry beans. *By* Ko Ren, 1800-1850. *See "Oni Yarai."*

510. IVORY. Manju. Kintaro as a child and his mother, Yaegiri, suckling him. *By* Rio Sen, 1800-1850.
See "Kintaro."

511. IVORY. Manju. Sho Chiku bei (three good emblems)—plum blossom, bamboo and pine. Reverse, conventionalized pine cones, bamboo leaves and plum blossoms. 1800-1850.

[39]

512. IVORY. Manju. Jurojin (God of Longevity) and deer. *By* Kosai, 1800-1850. *See "Sthi Fuku Jin."*

513. IVORY. Manju. Takaramono (luck emblems). 1750-1800. *See "Takaramono."*

514. IVORY. Manju. Cloud dragon carrying off temple bell, done in gold lacquer. 1750-1800.

515. IVORY. Manju. Chrysanthemum in Nashiji lacquer and Shibiyama. 1800-1850.

516. IVORY. Manju. Dragon in clouds. *By* Gyoku Hosai, 1800-1850.

517. IVORY. Manju. Three Chinese sages playing goban. *By* Hozan, 1700-1750.

518. IVORY. Manju. Map of Japan. *By* Nang yo, 1800-1850.

519. IVORY. Kagami Buta, with inserts—Shibooichi bronzes, gold and silver. The Tengu and Uskiwaka. 1800-1850. *See "Yoshitsune."*

520. BONE. Kagami Buta, with insert plate of Shakudo bronze, inlaid with Suaka and Shibooichi bronzes and gold. Shojo No performer. 1800-1850. *See "Shojo."*

521. KOHAKU (amber). Kagami Buta, with Shibooichi bronze insert of Dharuma, with eyes of amber. *By* Ey Dzui, 1800-1850.

522. WOOD. Kagami Buta, with metal center of Kibori Zogan (various metal inlays), on Shibooichi (silver bronze). 1800-1850.

523. IVORY. Kagami Buta, with metal plate of sheet gold depicting grasses on which is a cicada of Shakudo bronze. Reverse, bridge with pine trees and clouds in ivory. 1750-1800.

524. IVORY. Kagami Buta, with metal insert. Sculptor carving a stork, which takes flight. In Shibooichi bronze and other metal inlays. 1800-1850.

525. IVORY. Kagami Buta, with insert of Shibooichi and other metal inlays. Yoshitsune at Gojo no hashi. 1800-1850. *See "Benkei."*

526. IVORY. Kagami Buta, with insert of Shibooichi and other metal inlays. Benkei as a Yamabushi, reading scroll. 1800-1850. *See "Benkei."*

527. IVORY. Kagami Buta, with insert of Shakudo, silver and gold on Shibooichi panel. Miako Dori tied to a bamboo festive branch. 1800-1850.

528. IVORY. Kagami Buta, with insert of engraved Shibooichi bronze. Oni attendant spreading Shoki's toes. 1750-1800. *See "Shoki."*

529. IVORY. Kagami Buta, with insert of Shibooichi bronze and other metal inlays. Frog and willow. Frog depicted as a nobleman's pompous attendant. 1800-1850.

530. IVORY. Kagami Buta, with insert of Shibooichi and other metal inlays. Kusonoki Masashige, a great warrior of the 14th century. 1800-1850.
See "Onchi Sakon."

531. IVORY. Kagami Buta, with insert of Shibooichi, Suaka and Shakudo bronze and gold. Raiden (Thunder God), with drums in clouds. 1800-1850.

532. WALRUS IVORY. Kagami Buta, with metal plate and inserts of gold, silver and bronzes. Yemma Ten and a beauty—on screen. *By* Ten Min, 1850-1900.

533. IVORY. Kagami Buta, with bronze inserts. Monkey, persimmons and crab. Reverse, snail, caterpillar and leaves. *By* Ko Sai, 1800-1850.

534. IVORY. Kagami Buta, with Shibooichi bronze insert. Cherry blossoms. 1850-1900.

[41]

535. IVORY. Kagami Buta, with insert of iron, bronzes, silver and gold. Snow-capped house—with sliding Shoji—under pine tree by rocky cliff. 1800-1850.

536. IVORY. Kagami Buta, with insert of gold. Full moon with plum branch. 1800-1850.

537. IVORY. Kagami Buta, with insert of Gorossa bronze. The Aka Niyo, the male principal of the two guardian gods. 1850-1900.

538. IVORY. Kagami Buta, with insert of Gorossa bronze. The Sennin Tekkai—one of the eight Buddhist immortals. 1750-1800.

539. WOOD. Kagami Buta, with metal insert of Shiboo-ichi (silver bronze), with gold inlays. The curtain raiser and fox dancer. *By* Shomin, 1850-1900.

540. IVORY. Kagami Buta, with insert of Shibooichi bronze plate; reliefs in various bronzes, gold and silver. Three Chinese—Kwanyu, Gentoku and Choshi. 1800-1850.

541. IVORY. Kagami Buta, with solid plate of gold. The Chinese Emperor Cheng, creator of the great wall of China, is here shown with his retinue, overtaken by a rain storm and seeking shelter under a pine tree, which immediately shot forth additional branches and leaves to provide shelter. *By* Shu Raku. 1800-1850.

542. WOOD. Kagami Buta, with insert of Shibooichi and other bronzes and gold. Tama Yori Hime finding the arrow in the stream. 1750-1800.
 See "Tama Yori Hime."

543. PORCELAIN. Kagami Buta, with bronze insert. Conventional flower design in enamel, on both metal and porcelain. 1700-1750.

544. IVORY (oval). Kagami Buta, with insert of Shibooichi bronze. Manzai—New Year minstrel; rising, full moon. Pine bush in foreground. 1750-1800.

545. IVORY. Kagami Buta and ivory plate, with Shibiyama and metal inserts. The Poet Saigio Hoshi in contemplation of Usangi (white heron). 1800-1850.

546. WOOD, IVORY PLATE. Shinto dance with fox mask and Gohei in hand. 1750-1800.

547. TSUI TSHI (cinnabar lacquer). Manju. Chinese sage and pupils. 1750-1800.

548. LACQUER. Manju. Gourd in Nashiji lacquer. 1700-1750.

549. TSUI TSHI (cinnabar lacquer). Stand form— boy on hobby-horse. 1800-1850.

550. TWIN NUTS, CARVED AND LACQUERED. Landscape—castle by moonlight, water-wheel and men towing boat on moat. 1800-1850.

551. VEGETABLE IVORY. Nut with mask. *By* Tama Mitsu, 1850-1900.

552. NUT AND BRONZE, Falcon's claw (in Suaka and Shakudo bronzes), holding an acacia bean. 1750-1800.

553. NUT, SILVER MOUNTED. Perfume bottle. 1800-1850.

554. WALNUT. Falcon. 1850-1900.

555. CRYSTAL BALL. With crests of Prince Midzuno of Hizen. 1750-1800.

556. JADE, RED AND WHITE. Boy with fish. 1700-1750.

557. JADE. Karako (child) with boat and scull. 1700-1750.

558. SOAPSTONE. Frog. 1750-1800.

559. AGATE. Three gourds. 1700-1750.

560. CRYSTAL. Rabbit. 1800-1850.

561. JADE. Gourd. 1700-1750.

562. SILVER MOUNTED natural gourd "snuff" bottle; vine in gold lacquer. 1750-1800.

563. AGATE. Gourd. 1850-1900.

564. SILVER. Gourd bottle for perfume. *By* Setsuga. 1750-1800.

565. PORCELAIN. White Hirado. Oni mask. 1850-1900.

566. RAKU YAKI (porcelain). Blue Shishi seal. 1800 1850.

567. RAKU YAKI (porcelain). Red Shishi. 1850-1900.

568. PORCELAIN, Hirado. Temple bell inscribed with Buddhist writings. 1700-1750.

569. PORCELAIN, Imari. Monkey and gourd. 1750-1800.

570. PORCELAIN. Eggplant fruit and Kappa. 1800-1850.

571. PORCELAIN, Kiyo Midzu. "Hama Guri" (clam). 1800-1850.

572. WOOD, Shtan. Yatate (writing brush and ink-pad). 1800-1850.

573. COW'S HOOF. Mongaku doing penance under waterfall. Reverse, spirit of Kesa appearing before him. 1750-1800. *See "Endo Morito."*

574. WOOD. When closed represents a number of volumes of books (poems); open, shows the celebrated Roku Kasen (one poetess—center—and five poets). *By* Yoshi Nobu, 1800-1850.
See "Komachi."

575. WOOD, Kokutan. Copper coins. 1800-1850.

576. BRONZE. Coin form with Dikoku — God of Wealth. 1750-1800.

577. BEAR'S TOOTH. Edible bulb of the myoga flower. *By* Mitsuki, 1800-1850.

578. SILVER. A plum blossom with dice cube within, over which is the character of Ko ko ro, with a padlock attached. Plum blossom signifies "woman," dice signifies "gambling," Ko ko ro means "my heart."—"My heart is locked against women and gambling." 1800-1850.

579. BRONZE (Sentoku). Yoshitsune's helmet. 1750-1800.

580. BRONZE (Sentoku). Spider on leaf. 1750-1800.

581. BRONZE (Sentoku). Yatate (writing case with ink-pad and brush). 1750-1800.

582. BRONZE (Sentoku). Tow and flint lighter. 1700-1750.

583. BRONZE (Shibooichi). Compass, magnifying glass and sun-dial. 1750-1800.

584. BRONZE (Gorossa). Saddle tree. 1750-1800.

585. BRONZE (Sentoku). Winnowing basket for beans, with branch of maples. "The maple shows its beauty at winnowing time." 1750-1800.

586. BRONZE (Chinese). Chinese playing Go. 1650-1700.

587. BRONZE (Chinese). Vase with pheasant. 1650-1700.

588. BRONZE (Sentoku). "Good luck." Dikoku's mallet as a Yatate (ink, seal case and brush). 1700-1750.

589. TORTOISE SHELL. Head of bonito fish. 1750-1800.

590. BRONZE, WITH RELIEF SHIPPO (enamel). Sumi Tsubo (ink case). 1750-1800.

591. BRONZE (Shibooichi). Box. Niyo (one of the two great guardian gods). *By* Someen, 1750-1800.

592. BRONZE (Sentoku), BEATEN. Sumi Tsubo (ink case) "good luck" characters. 1600-1650.

593. BRONZE (Chinese), SILVER INLAID. Censer adapted to fire cup netsuke. 1650-1700.

594. BRONZE. The gourd sennin. 1650-1700.

595. IVORY. Mokugyo (temple drum), with gold insert of Shishi. 1750-1800.

596. WOOD. Two figures playing Go ban within a Nashi (pear). 1800-1850.

597. IVORY, SEAL BASE. San Kan—Chinese sage riding horse backwards to admire scenery from which he is traveling. 1650-1700.

598. IVORY, SEAL BASE. Monkey with armful of persimmons. From the story of the monkey and the crab. 1650-1700.

599. IVORY. SEAL BASE. Shishi pup. 1700-1750.

600. WOOD. Cubist rooster. 1850-1900.

601. WOOD. Cubist hen and egg. 1850-1900.

602. WOOD. Oni with pestle and mortar grinding tororo. *By* Kadzu Tami, 1850-1900.

603. WOOD. Snail and its shell. 1700-1750.

604. WOOD. Kirin (hybrid of horse and dragon). *By* Kaza Tora. 1850-1900.

605. WOOD (Kokutan). Omu Komachi. 1800-1850.

606. IVORY, SILVER AND CORAL. Jako iri (perfume holder). 1800-1850.

607. WOOD AND INLAY, LACQUERED. Figure in conch shell blowing conch shell bugle. "Blowing his own horn." 1750-1800.

608. WOOD. LACQUERED. Conch and two other shells. 1800-1850.

609. WOOD. Gama Sennin—saint with his frog. *By* Shugetz, 1800-1850.

610 WOOD, KUROI KAKI (black persimmon). The wrestling monkeys. *By* Shu getz, 1750-1800.

611. WOOD. Moso (filial virtue). "Moso's dream"— resting with his load of three mammoth bamboo shoots. *By* Hogan, 1800-1850. *See "Moso."*

612. WOOD. Cauterizing himself with an escharotic made of Yomogi. 1800-1850.

613. IVORY. Pine cone containing figures of Jo and Uba, the happily married couple, and their abode under the pine tree (emblematic of long married life). 1800-1850.

'614. IVORY. Wine bottle, with verse to the peony. 1750-1800.

615. IVORY. Fungi—an emblem of longevity. *By* Tani, 1800-1850.

616. WOOD (Kokutan). T'an T'ai and the dragon. *By* Sunetoshi, at the age of 68. 1800-1850.

617. IVORY. Shells, star-fish and crab. *By* Gyoku Ho-sei, 1850-1900.

618. IVORY. Three mice on old hat. *By* Gyoku Zan, 1850-1900.

619. WOOD. Riuto, Chinese sage. *By* Yama Masu, 1750-1800.

620. IVORY. Charm sparrow. *By* Masa nao I, 1800-1850.

621. WOOD. Barnacle-encrusted abalone shell with abalone in it. 1800-1850.

622. WOOD. Monkey-faced child. 1600-1650.

623. BRONZE. The Sennin, Jido. 1650-1700.

624. WOOD. Charcoal basket, Shibachi (tongs) and feather whisk. *By* Ren sai. 1800-1850.

625. SEA CORAL PINE AND IVORY. Branch with locust. 1800-1850.

626. IVORY. Puppy and young sparrow on zori (shoe). 1850-1900.

627. WOOD. Frog washing himself in bath tub. 1850-1900.

628. WOOD. Frog and snake. *By* Masanao, 1800-1850.

629. WOOD. Two frogs wrestling. 1850-1900.

630. WOOD. Pupa casing of a cicada. *By* Gyokushi. 1800-1850.

631. WOOD. Two peaches, branch and buds. 1800-1850.

632. DEER HORN. "Obake" (woman ghost). 1800-1850.

633. BRONZE. Ape's head. 1700-1750.

634. BRONZE. Shikami mask. 1700-1750.

635. IVORY. Mask of Adachi ga hara (the cannibal woman). 1800-1850. *See "Adachigahara."*

636. WOOD. Six masks. *By* Ishin sai Masanao. 1800 1850.

637. IVORY. Shishi. Reverse, basket work. 1750-1800.

638. LACQUER. Four chestnuts with leaves and branch forming a flower. *By* Riu key, 1800-1850.

639. IVORY. Spearhead. *By* Masa toshi. 1800-1850.

640. IVORY. Clamshell, crab and turtle. 1750-1800.

641. IRON AND SILVER. Crab. 1750-1800.

642. IVORY. Mushroom tied in old hat. 1800-1850.

643. DEER HORN. Kara shishi head. 1700-1750.

644. IVORY. Benten riding on deer, accompanied by
 Hotei, Dikoku and Bishuimon. 1850-1900.
 See "Sthi Fuku Jin."

645. IVORY. Dragon. *By* Tomo tada, 1750-1800.

646. METAL. Oni mask of Shibooichi and Gorosa
 bronzes. 1800-1850.

647. IVORY. Elephant. 1750-1800.

648 IVORY AND WOOD (Nara). Ono No Komachi
 (one of the six great poets), in her court dress.
 By Shuzan II, 1800-1850. *See "Komachi."*

649. IVORY. Gourds on vine. 1750-1800.

650. WOOD. The four meditating monkeys—two heads.
 By Deme, 1700-1750.

651. IVORY. Manju. Three helping monkeys. "Tom-
 oye" Mon form. 1750-1800.

652. IVORY. Manju. Human-faced cat. 1750-1800.

653. DEER HORN. Manju. Oni-faced bat in clouds.
 Reverse, octopus and sea waves. 1800-1850.

654. IVORY. Chinese figure. 1800-1850.

655. BONE. Hichiriki (musical instruments). 1750-
 1800.

656. IVORY. Okami (Goddess of Pleasure). 1750-1800.

657. GURI LACQUER. Manju. Kobako form. 1750-
 1800.

658. IVORY. Rabbit. 1750-1800.

733. IVORY SEAL. Senneen "Chokwaro" and gourd. 1750-1800.

734. IVORY SEAL. Chinese philosopher on bull. 1700-1750.

735. IVORY SEAL. Horse. 1700-1750.

736. IVORY SEAL. Deer. 1750-1800.

737. IVORY SEAL. Triple scroll. 1800-1850.

738. IVORY SEAL. Chinese plum blossom. 1800-1850.

739. IVORY SEAL. Cube with house, plum tree and bamboo. 1850-1900.

740. IVORY SEAL. Cube, Shishi and puppy, with movable tongue and eyes. Perforated Tama with lettered cube. 1800-1850.

741. IVORY SEAL. Juro Sukenari on his ride from Soga to Oiso. 1850-1900.

742. IVORY SEAL. Shishi. 1650-1700.

743. IVORY SEAL. Hakutaku. 1700-1750.

744. IVORY SEAL. Shishi Sennin. 1700-1750.

745. IVORY SEAL. Shishi and Tama. 1700-1750.

746. IVORY SEAL. Plain cube. 1800-1850.

747. IVORY SEAL. Plain cube. 1850-1900.

748. IVORY SEAL. Moso with hoe. 1850-1900.
See "Moso."

749. IVORY CUBE SEAL. Elephant and peony. 1850-1900.

750. IVORY CUBE SEAL. Shishi. 1850-1900.

751. IVORY CUBE SEAL. Moso tying two shoots of bamboo. 1850-1900. *See "Moso."*

752. IVORY SEAL. One of the Sambiki monkeys. 1700-1750.

753. IVORY SEAL. Chinese philosopher. 1700-1750.

754. NATURAL WALRUS TUSK ROOT—a seal—showing nerve passage resembling landscape of precipitous Chinese mountain. 1800-1850.

755. IVORY SEAL. Plain oval shaft. 1850-1900.

756. IVORY CUBE SEAL. Shishi top. 1800-1850.

757. IVORY SEAL. Chinese sage. 1700-1750.

758. IVORY SEAL. Sennin on Shishi. *By* Sey Gyoku, 1850-1900.

759. IVORY SEAL. Kanzan and Jittoku, as children, reading from a scroll of writings of the Zen Sect. 1750-1800.

760. IVORY SEAL. Dog. 1700-1750.

761. IVORY SEAL. Posturing frog under lotus leaf hat. 1800-1850.

762. IVORY SEAL. Shishi. 1750-1800.

763. IVORY SEAL. Deer. 1800-1850.

764. IVORY SEAL. Monkey-faced puppy. 1800-1850.

765. IVORY SEAL. Fan-shaped ivory cube. Seal of good wishes—"Pine, plum, bamboo, stork and turtle." 1800-1850.

766. IVORY SEAL. Chinese sage. 1750-1800.

767. IVORY SEAL. A Hollander. 1750-1800.

768. IVORY SEAL. Chinese philosopher and dog. 1700-1750.

769. IVORY SEAL. Uba (wife of Jo). Symbolic of long married life. 1650-1700.

770. IVORY SEAL. Group of seals, Shishi and rabbit. 1800-1850.

771. IVORY SEAL. Confucius in his youth. 1700-1750.

772. IVORY SEAL. Newt. 1800-1850.

773. IVORY SEAL. Okami (Goddess of Pleasure) with beans to drive out evil spirits. 1750-1800.
See "Oni Yarai."

774. IVORY SEAL. Two Shishis on rock. 1750-1800.

775. IVORY SEAL. Shishi. 1750-1800.

776. IVORY SEAL. Shishi. 1750-1800.

777. IVORY SEAL. Dog. 1700-1750.

778. IVORY SEAL. Kirin. 1800-1850. *See "Kirin."*

779. IVORY SEAL. Moso in bamboo grove (emblem of filial devotion). 1750-1800. *See "Moso."*

780. IVORY SEAL. Chinese sage. 1700-1750.

EXPLANATORY NOTES

ADACHIGAHARA.—Known as the woman cannibal goblin. She had been a lady of rank in the court of a powerful noble who was suffering from a disease requiring human blood from young people. *Attribute:* A large knife.

ASA HINA SABURO (historical and legendary).—A twelfth-century warrior of great strength, who, having subjugated the Oni, was received and entertained by Yemma, King of Hell.

BENKEI (historical).—A great warrior of the twelfth century. The son of a Buddhist priest who during his youth became a wandering priest. He grew to be a man of great strength and stature and followed the sword for a livelihood, excelling with the spear. At "Gojo" Hashi (bridge), in Kiyoto, where he had been in the habit of challenging all passing Samurai successfully, he first met the youth, Yoshitsune, by whose great agility and swordsmanship he was overcome, and thereafter Benkei became his faithful follower and companion till death.

BUMBUKU-CHAGAMA.—An iron hot-water pot which had the miraculous power of assuming the form of a badger and which brought fear to its many possessors, till it fell into the hands of a tinker, who, treating it kindly, was rewarded by its publicly performing its antics for him, by which he gained great wealth.

DHARUMA.—A wandering priest, believed to be of Hindoo descent, who founded the Zen sect of Buddhism in China and finally settled in Lo Yang, where he went into seclusion and sat in meditation for nine years till his legs rotted away. *Attributes:* A long hair whisk, a Nyoi (baton) or a Mokugyo (wooden drum).

ENDO MORITO (deified as Mongaku Shonin).—A noted warrior of the twelfth century who became enamored of Kesa, the wife of a Samurai. She resisting his entreaties, he vowed to destroy her family unless she aided him in killing her husband.

Planning to admit him on a certain night, Endo came and cut off the head of the sleeper in the appointed room, only to find he had killed the woman herself, who, in her husband's absence, had dressed herself in his clothes and sacrificed her life to save her honor. Endo, overcome with grief, became a monk and did penance by standing under the Machi waterfall.

[53]

FILIAL DEVOTION.—An old farmer, while resting from planting his fields, was bemoaning the fact that he was without sons, and exclaimed that he would gladly give one of his daughters to anyone who could plant and harvest his fields. He was overheard by an ape, who took him at his word, and most successfully completed the season's work, whereupon he demanded the fulfilment of the pact.

The old man in sorrow told his daughters of the bargain. The two eldest declined to consider it, but the youngest consented rather than that her father's word should be broken. On her departure to the mountain abode of the ape she took with her a bag of beans, the grains of which she dropped on her way. The winter passed, she murdered the ape and returned to her father guided by the growing beans.

FUJI HIMÈ.—The divine princess of Mount Fujiyama, the goddess who causes the trees to blossom. *Attributes:* Large pilgrim's hat and branch of wisteria.

KAPPA.—A hybrid of frog and the turtle, a mythical goblin of the river. His power floats in a liquid in a hollow on the top of his head, and he is a great mimic. Its evil doings are perpetrated mostly on children, who, if they meet him and will but politely bow, he will copy them and in so doing spill his liquid power. He is passionately fond of cucumbers.

KINTARO.—Literally, "The Golden Boy." Known as the powerful child of the forest, where as a babe he was lost by his mother, Yaegiri, and found by Yama Uba, the mountain nurse, by whom he was reared. His companions were the creatures of the forest, with whom he indulged in feats of strength and agility. *Attributes:* An axe, the bear, deer, monkey, hare and the Tengu.

KIRIN.—A mythical animal, hybrid of horse or unicorn and dragon; a paragon of gentleness to the universe.

KOMACHI.—The celebrated beauty, most brilliant woman and noted poetess of the Rok Kasen (six great poets) of the ninth century, who in the prime of life, indulged in the greatest luxuries and highest court favors, and in her old age was reduced to the lowest stage of poverty.

MIKAWA MANZAI.—The New Year strolling minstrel and dancer, usually one Manzai dancer and one Saizo performer. *Attributes:* Hand drum and fan.

MOMOTARO.—The wife of a poor woodsman picked up a very large peach which she took home to her husband, who upon opening it found a tiny boy child in place of the kernel. They named him Momotaro—first son of the peach—and

under their loving care he grew to be a youth of great agility and strength. Seeking adventure, he set out to conquer Oni ga shima—the devil's island—and on his way he met a dog, a monkey and a pheasant. With his three companions he overcame the king of the Oni and returned with his boat full of inexhaustible treasures which he gratefully laid before his foster-parents.

Moso (from the Chinese).—One of the twenty-four paragons of filial virtue. Moso, a youth of the third century, whose ailing mother, during the depth of winter, craved a dish of stewed bamboo shoots, and though the bamboo does not send forth its shoots till spring, he strenuously sought through the snow-covered bamboo groves till he found some. *Attributes:* Straw hat, straw coat, hoe, bamboo shoots, bamboo and snow.

Onchi Sakon.—A noted spy and retainer of the great warrior Kusanoke Masashige, who, disguised as a monkey showman, gained valued information of the opposing forces of the Hojo Takatoki at the battle of Aka Saka.

Oni Yarai.—The New Year ceremony of driving out the Oni or evil spirits and calling upon luck to enter the house for the coming year, enacted by the head of the family casting roasted black peas, of which the Oni has a great horror, from a grain measure box.

Sambosa.—The leading characters in an ancient religious dance. Dress worn is designed with stork and pine—emblems of longevity. *Attributes:* A rattle, fan and long, conical-shaped hat.

Shibiyama.—Shibiyama is the term by which inlays of shell and other substances on wood or ivory are generally known, from having been first produced in a masterly manner by one named Shibiyama. The master pupil or deshi of each succeeding artist is entitled to the name Shibiyama.

Shishi.—The Buddhist guardian lions or dogs resembling the hybrid of lion and curly-headed Chinese dog. Sometimes known as the "Dog Fo" and "Kara Shishi." *Attributes:* The peony and Tama (sacred jewel ball), associated with waterfalls and cliffs, from the top of which they cast their offspring to test their vitality.

Shi Shi Mai.—The lion-dog-faced mask and cape worn in the "Kappore" and "Dai Kagura" dances; also used by the New Year dancers and the strolling street boy dancer.

Shita-Kiri-Tsuzumi (tongue-cut sparrow).—A cross old woman having caught a sparrow eating some of her starch paste, cut its tongue out, and upon one kind old man, her

neighbor, inquiring of her if she had seen his pet sparrow, learned of the act. Deeply grieved, the old man set out for the forest in search of the sparrows' colony, where he found the abode of his pet, and within, the tongue-cut sparrow, surrounded by his family, who gave the old man a most hearty welcome and entertained him with the "sparrow" dance. On taking his departure they proffered him the choice of two baskets, one large and one small. He chose the latter and on opening it upon his return found, to the delight of himself and his wife, that it contained an inexhaustible supply of treasures.

The heartless old woman neighbor, learning the story of their good fortune, paid the sparrow family a visit, and upon her departure was also proffered the choice of two baskets. She chose the largest, and on opening it found nothing but goblins.

SHIYEI (from the Chinese).—The Sennin (saint) who journeys on the back of a carp. In life, whilst fishing, he caught a red carp, which he kept and cared for in his pond; at his death his spirit was carried to heaven by the carp.

SHIZUKA.—The great Yoshitsune on his retreat from Yoshino presented Shizuka, his concubine, whom he left in the care of his retainer, Tada Nobu, with a Tsuzumi (ladies' hand drum), made from the skin of a female fox. The spirit of the fox sought to recover its mother's skin by assuming the character of Tada Nobu.

SHO CHIKU BEI.—The three decorative good wishes—Long life, love, and happiness. Pine, longevity; plum blossom, love; bamboo, happiness.

SHOJO.—Wine imps—mythical creatures bearing a human head with long, red hair. They are passionately fond of wine and delight in frolicking about the sake jar. *Attributes:* Long wine ladle, sake cup, sake jar and long-tailed tortoise.

SHOKI (the demon destroyer).—Said in life to have been an imperial student who, from chagrin at his failures, committed suicide, but by special order of the emperor was buried with high honor. His spirit in gratitude sought ever after to deliver the nation from the evil powers of the Oni, or demons. *Attributes:* A double-edged sword and large hat.

STHI FUKU JIN (seven household or lucky gods).—*Daikoku,* God of Wealth and Prosperity. *Attributes:* Mallet, sacks of rice and rat. *Yebisu,* God of Food—the fisherman. *Attributes:* Fishing-rod and fish. *Hotei,* God of Happiness and Lover of Children. *Attributes:* Bag of treasures and fan. *Bishia Mon,* God of War—Chinese god of wealth and pow-

er. *Attributes:* Helmet, spear and shrine. *Fuku Roku Jin,* God of Wisdom. Shown with elongated head. *Attributes:* The Tama (sacred jewel) and deer. *Juro Jin,* God of Longevity. *Attributes:* Staff, scrolls and stork. *Benten,* the Goddess of Love and Purity. *Attributes:* The biwa (guitar) and dragon.

TADA MORI.—The Temple of Giyonji was reported to the mikado as infested by a dragon who threw off flashes of light through the grounds. The noted warrior Tada Mori proffered to destroy the monster and, while waiting in the shadow of one of the temple lanterns, discovered that the monster was but the ragged old lantern-tender, who carried a torch, which, as he blew on it, threw off flashes of light.

TAKARA MONO (emblems of prosperity).—Attributes of the Stki fuku jin (seven luck gods)—notably of the contents of Hotei's bag and the cargo of the Takara bune, or Ship of Plenty, comprising: Rolls of brocade, scrolls, key, purse, coins, hat, raincoat, the sacred gem, coral branch, Daikoku's mallet, Hotei's fan, etc.

TAMA YORI HIMÈ.—The daughter of Kamo no Takètsumi found, floating in a stream, a red arrow, which she took home with her. Shortly after she showed pregnancy, but declared ignorance of the father. When the child reached the age of five, Yama Yori's parents made a test, in the hopes of discovering the boy's father, by giving a fete to which all the villagers were invited, whereat they gave the boy a cup of wine and told him to take it to his father. The boy at once took the cup and placed it before the arrow.

TENGU.—The imps of the forest and attendants of Dai Tengu, God of the Woods. They are of two classes—one having human-appearing head with elongated nose and bird's wings, known as Konoha Tengu, the other semi-bird form, with beak of the crow, known as "Karasu" (crow) Tengu. *Attribute:* Egg and clouds. *Attribute* of Dai Tengu—the seven-feathered fan.

TOBO SAKU (from the Chinese).—A sage of the Han dynasty who received from Hsi Wang Mu (Goddess Mother of the West) one of the immortal peaches. He is likened to Juro Jin (God of Longevity of the Japanese seven Lucky Gods) *Attribute:* One or more large peaches.

URASHIMA (the fisher boy).—One day whilst fishing from his boat he caught a tortoise, and, mediating on the longevity of the tortoise—believed to be a thousand years—decided rather than deprive it of so many years of life to return it to the sea. Falling asleep in his boat the spirit of the tor-

[57]

toise—the Sea Goddess—appeared and invited him to ac-
company her to the palace of the sea king "Riu Jin"—her
father—who adopted him and gave him his daughter in
marriage, where he lived happily for three sea years. One
day, begging that he might see his father and mother, the
Sea Goddess presented him with a casket, charging him not
to open it if he desired to return to her. Setting out on the
back of a large tortoise, he soon returned to his native
shore, where, upon inquiring as to what had happened to
his home and parents, he learned they had been dead for
three hundred years. Wishing to return to the Sea Goddess,
in his sorrow, he forgot her injunction, and thinking the
casket might contain directions, he opened it and was im-
mediately transformed into a decrepid old man, dying
shortly after.

YEMMA TEN.—One of the twelve Deva kings and known as
the King of Hell—the recorder of evil deeds.

YOSHITSUNE (historical).—The most beloved hero of Japan,
and one of the most noted warriors, was the half-brother
of Yoritomo—the first shogun (tycoon)—whom he ma-
terially aided and by whom, through jealously, he was
afterwards betrayed. It is said that his remarkable agility
and feats of swordsmanship were gained by his association
with the Tengu (spirits of the forest) in his youth, and due
to their teachings overcame Benkei at the Bridge of Gojo.
One of his many escapes from the wrath of his brother
was secured by his loving follower Benkei assuming the
character of Yamabushi, a mountain warrior priest, with
Yoshitsune as his novitiate. Yoshitsune's child name was
Ushiwaka.

THE END